Art and the Question of Meaning

Hans Küng

Art and the Question of Meaning

Translated by Edward Quinn

Crossroad · *New York*

1981
The Crossroad Publishing Company
18 East 41st Street, New York, NY 10017

Originally published as *Kunst und Sinnfrage*
© Copyright 1980 by Benziger Verlag Zürich Köln

English translation copyright © 1981 by
The Crossroad Publishing Company

Printed in the United States of America

Library of Congress Cataloging in Publication Data

Küng, Hans, 1928–
 Art and the question of meaning.

 Translation of Kunst und Sinnfrage.
 1. Aesthetics. 2. Art, Modern—20th century.
3. Meaning (Philosophy) I. Title.
BH39.K7613 700'.1 80-27049
ISBN 0-8245-0016-4

Contents

Art and the Question of Meaning

Meaningless Art?

Is it true, as we frequently hear, that the atmosphere prevailing in contemporary art circles can be assimilated to that of Rembrandt's well-known group picture "Anatomy of Doctor Tulp," with a lot of doctors fussing around and trying to patch up what remains of modern art—as corpse, half-dead patient, or one worth reviving (Eduard Beaucamp)? And if theologians are also brought to the sick bed, then many people will really get a shock. Has it already come to this?

Perhaps indeed there is nothing left but prayer. Prayer for recovery? Don't worry. I have no intention of administering publicly the last sacraments to the supposedly dying patient. Neither do you— for your own part—expect any miracles from the theologian, nor—I hope—any prophetical clairvoy-

ance with regard to the remaining possibilities and future prospects of the *visual arts*. And it is with these that we are concerned, although there are similar phenomena also in architecture, music, and literature. What you can expect from a theologian is a contribution to sober diagnosis, to understanding, and perhaps also a little hope. Let it then be said from the very beginning that I am not abandoning the patient. I believe in his recovery.

One difficulty has to be faced. There is *not a generally recognized definition of art* any more than there is a generally recognized definition of religion or philosophy. But there can be no doubt about the reality of art. The twentieth century in particular is characterized by a variety of attempts again and again to find a new definition of art, to get rid of the traditional idea of art as too narrow, and especially not to restrict a priori the idea of visual art to certain fields. As a theologian I can leave the question of the definition of art to art historians and art theorists. Even if there is no undisputed definition of art, there is unquestionably a *reality of art*. I am starting then, not with a definition of art but with the reality of art, with the knowledge that art exists whatever its forms and frontiers may be.

Art and meaning. For many people today these two ideas seem to exclude rather than to include each other. I am thinking not only of the large number of those who never go to an exhibition, who find abstract and nonrepresentational art in particular meaningless; and who react unsympathetically, rejecting it emotionally, even though it

has to be supported by large subsidies from taxation. I am thinking mainly of the numerous lovers of art who long ago accepted the classical modern style—van Gogh and Cézanne; Picasso, Braque, Léger, and Matisse; Kandinsky, Mondrian, Chagall, Kokoschka, and Klee; *Die Brücke* and *Der Blaue Reiter*; Giacometti and Moore; up to Max Ernst and Dali—but are now asking whether all that came after has taken us very much further: whether all the new experimental arts and techniques, connected especially with America's triumphal entry into the universal history of art; whether, that is, action painting, color field and hard edge painting, op art and pop art, or even photo-realism and mixed media arts, represented a really fruitful further development of modern principles or merely their repetition, dilution, and dissolution. And I am ready to admit that I myself have had doubts and wondered what contemporary art will do next. What leitmotifs of our century have not yet been given artistic shape, what principles of form have not yet been subjected to thorough experimentation, what new techniques have not yet been tried, what artistic "action" not yet started, what bold happening not yet staged, what taboo not yet infringed? Is it possible to surpass what has hitherto been attempted? Whether geometry or dreams, whether the sophisticated or the banal, whether *objet trouvé* or environment, whether aluminum, polyester, or excreta, nails, rags, or scraps of food, whether op, pop, or porn, whether monochrome, informal, serial, or conceptional, whether quotations from illustrated papers

and posters or persiflage of sacrosanct master-works; experiments have been made with all these things—up to the final consequences.

I hope I shall not be misunderstood. I am not thinking of lumping everything together and over-looking the great achievements which have been produced precisely with the new materials. I am not one of those who deny a priori any creative vitality and possibility of innovation to modern art. I know of course that the great masters were never conservatives, but innovators; that most de-scriptions of styles began as terms of abuse. And how often have people talked about art coming to an end and found their prognoses belied by sur-prising further developments. And yet I find it dif-ficult to come to terms with some of the more con-spicuous contradictions of the present art scene. There are so many provocations which are no longer provocative; so many protests addressed to no one in particular; so much publicity and so small a public; so many antiacademics in the acad-emies; so many revolutionaries financed by the Es-tablishment; so many artists who live quite well on what they proclaim to be the "death of art," the "renunciation of art," and the "art of artlessness."

The question is thus thrust upon us: Has mod-ern art in its most recent developments not per-haps itself destroyed the heritage of a thousand-year-old history and thus great potentialities of meaning? With its radical questioning of all aes-thetic methods and norms, is it not exposed to the danger of destroying its own meaning, its great significance for men, of conjuring up its own end?

You must pardon me if I raise the heretical question: Is not art too important to be left to artists?

Today, unlike ten years ago, even such knowledgeable and sympathetic interpreters of contemporary art as the Englishman Edward Lucie-Smith, the German Eduard Beaucamp, the American Sam Hunter, or the doyen of Italian art historians, Giulio Argan, are writing about the "crisis of the avänt-gärde." Argan, the Italian Marxist, himself the editor of a representative *Art History of the Twentieth Century* (1977), in a profoundly pessimistic introduction to the latest Propyläen volume on *Art of the Present Time,* maintains that, after a great number of vital driving forces and outstanding personalities in the first decades of the present century, soon after the Second World War, the signs appeared of a crisis which now after thirty years in spite and because of enormous art production has reached its peak. Art, so Argan thinks, like alchemy in its day, has lost its function; but it remains virulent in man's subconscious and consequently finds expression in such surprising forms as those multifarious "actions" of "artists" which to many people seem arbitrary and pointless. "It is a question however," says Argan, "not only of a crisis of art, but of a whole culture—the humanist culture—of which history was the supporting framework. Art was of course an essential element in this culture; and as it is impossible to conceive a humanist culture without art, it is equally impossible to imagine a survival of art in a nonhumanist culture."

People are beginning to wonder if art is becom-

ing increasingly functionless, meaningless, point-
less, as for many belief in God is also futile, al-
though there were some who thought for a long
time that God could not die. Will not our museums
soon become merely the ancient temples of an art
lately deceased, just as, according to Nietzsche,
our churches are now the tombs of the God who
died long ago? We visit them, look round them,
but no longer pray in them. All that remains is a
secret longing for something that once was there
but can no longer exist today.

It may seem paradoxical that the progressive
criticism on the part of the Marxist Argan, after
precisely thirty years, appears to have caught up
with the conservative criticism which the former
party-comrade and now professing Christian Hans
Sedlmayr published. His work, *Loss of the Center*
(the title has become proverbial), was a passion-
ately concerned, even fanatical, plea against the
pressure for autonomy, for the purity of the arts,
against the modern principles of pure architec-
ture, pure painting, pure drawing, against the de-
mands for constructional truth and material authen-
ticity, against abstraction, relevance, objectivity.
All these, according to Sedlmayr, represented ut-
terly disastrous absolutizations and polariza-
tions which, in a rational-constructivist or in an
irrational-surrealist way, were bound to lead to an
alienation of the arts from one another and to the
dissolution of art all together. This dissolution he
saw manifested especially in the turning to the
lower spheres, to the primitive-barbaric-archaic, to
the extrahuman-inorganic-mechanical, and often

even to the pathological, morbid, chaotic—all to the neglect of the higher, spiritual, humane, metaphysical. On the path of modern autonomy then, according to Sedlmayr, there is increasingly a loss of that center of meaning which in fact is man, between sense and spirit, lower and higher, man not as autonomous agency, but as God's image: the God-man. . . . But—we must not jump to conclusions—none of this was meaningless history.

Not a Meaningless History

Although still regarded by some religious critics of modern art as the root of all evil, man's autonomy is accepted in our time, at least in principle, even by churches and theologians. It proved to be a historical necessity at the latest from the time when the earth had ceased to be the center of the universe and man had learned to see himself as the center of the human world he had constructed. Like other spheres—science, economy, politics, law, state—so too culture and art had to be brought directly under man's responsibility and control and withdrawn from the direct influence of the churches, of theology and religion. The autonomy of art, as it emerged in practice and theory from the time of the Renaissance onwards, acquired its philosophical-critical foundation two

centuries ago with Kant's *Critique of Judgment* (1790). From the time, therefore, of the revolutionary turning point from the eighteenth to the nineteenth century art also has been increasingly understood in its own light, explained and at the same time shaped according to its own immanent laws—in the history of that modern art which need not fear comparison with any former epoch of art history.

For who could deny that the extraordinary intensity and variety of the questioning of the phenomena of our visible world by art has truly produced much more than merely destructive effects? Even the most conservative criticism of art will not want to overlook the experiences of structure, of color, of sculpture, attained with the classical modern styles. Only those born blind or willfully blind could fail to realize what impressionism, fauvism, and expressionism, what cubism, futurism, constructivism, as well as dada and surrealism, have discovered for us by way of new horizons, bestowed on us by way of wealth of invention, revealed to us by way of bold experiment. From the time of that epochal turning to the modern age in art also, color, light, line, surface, the three-dimensional have become visible and expressible with a completely new clarity and directness, the different art forms have entered into a fruitful symbiosis. New kinds of material and techniques have permitted the boldest dreams to become reality also in sculpture and architecture. The art of the present century has brought us an unexpected transcendence beyond our banal, everyday one-dimen-

sionality, surprising extensions of our experience of reality, an immense intellectual gain in the discovery and penetration of the dimensions in depth of our existence.

Much that had to do with the creative freedom of constructive imagination, with the quest for origins, with striving for truth, for purity of the elements, pure color, line, surface, functional architecture, with the love of geometry, of technology, of the machine, with the development of an abstract or freshly concrete, absolute art, is taken for granted by us today. And, contrary to all the gloomy predictions, this art has also been able to give form to sacral materials (we may recall Rouault's, Nolde's, and Manessier's great works and the portrayals of the Crucified by Corinth and Slevogt, Gauguin and Ensor, Beckmann and Schmidt-Rottluff, Arp and Malevitch, Baumeister and Buffet); this art has also been able to create sacral spaces especially in France, Germany, Switzerland, and Holland; in Le Corbusier's Ronchamp, in Léger's and Bazaine's windows of Audincourt and Courfaivre, in Chagall's biblical cycles of Zürich, Jerusalem, and Nice, in Henri Matisse's chapel of Venice, it has reached truly classical heights. Should we not then constantly take to heart Jakob Burckhardt's admonition: "As long as it is living, art seeks to create what is perpetually new; and it is not presumption on the part of the artists, but an inner necessity, that makes them produce something new, something that has never existed before"?

I will not go on at greater length here, but sim-

ply state quite firmly that the dramatic history of modern art was certainly complex and problematic, but not meaningless: it was never meaningless. And yet at the same time I wonder if this kind of factual-practical answer is an adequate response to the question of art and meaning. It seems to me that the fundamental question arises only at this point.

The New Question of Art and Meaning

I am well aware of what an extremely complex, difficult, and even delicate question I have let myself in for here. It is however a question that has continually been raised ever since Plato, Aristotle, and Plotinus, Augustine and Aquinas raised it with reference to the beautiful, and particularly after Wolff's disciple A. G. Baumgarten had developed a science of aesthetics (forty years before Kant's third *Critique*) and raised what had hitherto been discussed only marginally to the level of a specifically academic discipline. Once again, I have no intention of discussing here the almost innumerable descriptive or even normative definitions of art and theories of art which have emerged since then.

I prefer to come directly to the modern or, if I may so describe it, *new question* of art and meaning.

What is to be understood here by "meaning"? As you know, in connection with art, the important distinction has been introduced between the meaning and the purpose of a work of art. That is to say, genuine art has a meaning, something that justifies the work of art in itself; but art as such has no purpose or use. Indeed, a work of art designed to be useful or to serve certain interests is a betrayal of art. It is true that works of art may have been created for a definite purpose (works commissioned for public sculpture, portraits, arrangement of rooms). But they must never be merely means to an end. They count as art only if the element of the nonfunctional, disinterested, useless-playful is dominant. According to Kant's paradoxical expression, what is purposefully without purpose can be called beautiful. As "truth" in the last resort has meaning in itself, so too with the work of art: in the last resort it is created simply to be, to please, to reveal.

The word "sense," sometimes used as synonymous with "meaning," is described by Hegel as a "wonderful word." This, he says, is because it is "used in two ways that are mutually opposed." First, "it designates the organs of immediate apprehension (that is, pure sense organs); but it also refers to the meaning, the idea, the universal implications of the thing."

Thus "sense" refers both to the "immediately external" and also the "inner nature," which of course is not conceptualized, but only "surmised"

in the contemplation of the work of art. With the "meaningful" consideration of a work of art, according to Hegel, the important thing is to distinguish but not to separate these two aspects. The work of art is a unity of sense datum and sense. The meaning or sense of the work of art then lies in the senses, but not only in the senses: it lies in the new context of meaning accessible to the senses. This is what I might describe as the *immanent sense* of the work of art.

Such immanent contemplation however overlooks an important aspect. Certainly art is autonomous, but it is not autarchic. Art is related to society and every work of art is actually action on and reaction to sociopolitical conditions. Autonomous, "pure" art and socially critical "committed" art are not exclusive opposites but are related in a dialectical tension. But, instead of talking about a sociopolitical "meaning" of a work of art, it would be better to speak of a sociopolitical "purpose" or more generally of a sociopolitical "dimension." For no work of art, however committed—so far as it really is a work of art—has strictly speaking a sociopolitical *meaning;* otherwise it would be sheer propaganda or agitation. But, conversely, every work of art, however "pure," has a sociopolitical *dimension,* acknowledged or not, and many a great work of art—we may recall, for instance, Hogarth, Goya, Grosz, Dix, Kollwitz, Bechmann, Picasso— has also an explicit sociopolitical *purpose* (or intention).

As you know, there has been considerable, vigorous discussion in the last two decades about this

sociopolitical dimension of art, its emancipatory, en-
lightening function, its de-restriction, democrati-
zation, public character, an appropriately extended
art education, the relationship between "aesthet-
ics" and "politics." By comparison with the other
media, particularly the spoken and written word,
and even politics, the possibilities of the visual
arts for the direct formation of political awareness
and for real change of social conditions and struc-
tures have admittedly turned out to be extremely
limited. Art can indeed make its mark on con-
sciousness and thus, indirectly, change society,
but this cannot be brought about instantaneously,
only as a long-term effect. At the same time, artists
themselves are increasingly expressing misgivings
in regard to the politicizing and erosion of the no-
tion of art; are stressing the limits to commonplace
art, to kitsch, and to the anonymous product of the
picture industry; are raising afresh the question of
artistic quality and demanding better training in
handicrafts and technology as a part of general ed-
ucation.

But, instead of dwelling on this much discussed
theme, I would like to provoke reflection on what
has hitherto been scarcely made into a theme:
what I have called the new question of art and
meaning. Should not both the immanent meaning
and the sociopolitical dimension of art be seen in
a very much wider context, in the total context: I
mean the themes of *art and the meaning of life, art
and total meaning?* Do not hastily dismiss this as a
purely private question! If the question of the
meaning of human life, of the history of humanity,

of reality as a whole, today remains unanswered for so many people, this is a political factor of the greatest importance, which fortunately is being increasingly recognized as such even by politicians. I am not a pessimist. But there is no need of any lengthy discussion of the fact that we are involved in a crisis of orientation on the grand scale, into which all previous agencies of orientation, traditions of orientation, standards of orientation, have been drawn. We are threatened by a comprehensive crisis of meaning and it would be odd if art— as a delicate seismograph—did not reflect it. No, there is no doubt that the crisis of art must be seen against the background of the general crisis, outwardly of norms, inwardly of values, and thus profoundly of meaning. Can art itself, visual art, make any contribution to overcoming this crisis of meaning? Thus we come to the decisive question.

Basic Trust or
Basic Mistrust in Art?

Can art, should art, provide a direct and final anwser to the question of meaning? No, unless art itself is to become a religion. And religion of course is just what it has been for a long period in modern times. In German Classicism and Romanticism—long after the "age of Goethe" and its basically pantheistic mood right up to Nietzsche—art was deified, elevated to be a *religion of art*. Art, supposedly of divine origin, was regarded as a necessity in face of the threat to humanity, as having an uplifting, redeeming, reconciling function, as redeeming from life and reconciling with life. This was *re-ligio*, re-connection, as reconnection with life. The artist, especially the poet and later the

27

tone poet, the composer, was thus regarded as the inspired genius, the true creative man, the intuitive seer. The work of art was seen as the new revelation and the theater, later the opera, pantheon of the art, as a sacred shrine to which people went as they had formerly gone to church, on pilgrimage as formerly to a place of pilgrimage. Bayreuth especially became a quasi-religious symbol, center of that complete work of dramatic art which draws on the services of the two triads of art: architecture, sculpture, and painting and likewise dance, music, poetry. "Man's supreme purpose is art," proclaimed Richard Wagner in his book, *The Work of Art in the Future,* which appeared in 1850.

Today however—after all the bitter experiences of our century—this work of art certainly has the future no longer before it, but only behind it. Hegel, who always clearly distinguished between art and religion and wanted to have art subordinated to religion, saw more deeply and rightly proclaimed the end of *this* art. No one today assumes that churches could be replaced by museums, worship by theater, primordial records of religion by monuments, priests by artists, revelation by aesthetics: in a word, religion by art. The religion of art proved to be an artificial religion for the educated middle classes. And eventually Bayreuth too was demythologized, first historically by the national socialist "twilight of the gods" and then artistically by the modern practice of unromantic presentation, which of course has its difficulties from the start—not to speak of genuine miracles—with the wondrous swan of Lohengrin.

The decision factor, however, is that in the present century the basic mood particularly in art circles has frequently turned into its opposite. Art is no longer regarded as religion, as absorption of man into the divine world, as man's supreme purpose. Art has now become the expression of man's estrangement, his isolation in the world, of the ultimate futility of human life and the history of humanity. Art is seen then no longer against a pantheistic but *against a nihilistic background*. I say this as diagnosing, not as moralizing. It is this nihilistic background which enables us to raise the question of art and meaning today in a wholly new, an ultimate radicalness. The sea drunk up (a bleak emptiness), the horizon wiped away (a living space without prospects), the earth unchained from its sun (an abysmal nothingness); with these three powerful metaphors Nietzsche a hundred years ago clear-sightedly announced the advent of nihilism—today often so banal, ordinary, superficial—in order to ask: "Is there still any up or down? Are we not straying through an infinite nothing? Do we not feel the breath of empty space? Has it not become colder? Is not night continually closing in on us?"*

What some people feel only vaguely and superficially many artists go through consciously, intensively, and painfully. The deeply pessimistic, often nihilistic, basic mood (announced, for instance, by

*The quotation from Nietzsche is from *The Gay Science*, trans. Walter Kaufmann (New York: Vintage Books, Random House, 1974), p. 181.

Goya, expressionists, dadaists, surrealists) has now become a widespread phenomenon. This was brought home to me personally by the recently deceased Lucerne painter Max von Moos who, with the aid of surrealist methods, had turned a comprehensive life's work in about a thousand pictures and twenty thousand drawings full of strange dream ideas and visions of terror into horrifying images and messages. In his obituary in a leading German newspaper it was said that this painter had thus made clear not only his own situation but that of modern man as such: modern man, a slave to blind and evil lust for life, now afflicted with his nightmares, without finding hope or mercy. These were the "sad truths" of an artist tormented by grave fears which his unconscious had conjured up before him throughout his whole life: sculptured confessions of a nihilist who after reading Nietzsche had lost his belief in the Church but not in hell.

After Nietzsche, Baudelaire, Camus, no one has analyzed more seriously and acutely this question of nihilism against the background of nihilism than Theodor W. Adorno in his *Aesthetic Theory.* Can works of art still be meaningful at a time of meaninglessness? This is his question. Certainly the great tradition of aesthetics and art has always seen the work of art as a synthesis of meaning. But what happens to this synthesis of meaning if in the course of modern development the idea of a preexisting divine order of meaning has been increasingly shattered and thus meaning itself has become more questionable? Can the individual

work of art still be meaningful when the great synthesis of meaning no longer exists? Adorno's answer is that, in a time of meaninglessness, the work of art can symbolize *meaninglessness* very precisely in a way that is aesthetically completely meaningful—that is to say, inwardly harmonious—and does so to a large extent in modern art. The work of art is thus an expression meaningful in itself of the actually existing meaninglessness. "Even before Auschwitz," says Adorno, "in face of historical experiences, it was an affirmative lie to ascribe to existence any meaning at all" which might have had "consequences even for the form of the work of art."

An "affirmative lie"? It is true that I can deny any sort of positive meaning to existence. Every man, and the artist in particular, because of his sensitivity and his often broken relationship to society, is faced with the alternative of nihilism, with the radical antithesis to the affirmation of a meaning of life, with the possibility of a *No* to reality as a whole, of *basic mistrust*. In a spirit of revolt, of resignation, or simply cynicism, he can regard everything—his own life, art, the whole world—as in the last resort futile, absurd, chaotic, illusory, null. And he can express this mistrust in regard to reality in his art, in aesthetically harmonious and even finished images.

He can. But—and Adorno does not examine this alternative—he need not. Even in face of all "historical experiences" and with all his appreciation of the abysmal uncertainty of his life, of the world, and even of his art, he can adopt a different basic

attitude. Despite all the absurdity, emptiness, meaninglessness, thrust upon him, he can hold fast to a fundamental value and meaning of his life and of the world as a whole. While obviously always sustained by other human beings, even though tempted to reject it, he can still in principle accept reality in all its uncertainty: without superficial optimism, without any affirmative lie; therefore, instead of a basic mistrust, there can be a *basic trust*. And he can give expression to this basic trust in his art, even in consciously ugly, critical, provocative-negative images. This has largely happened in modern art (and not only in religious art).

This means that no human being and no institution, neither state nor Church, nor any philosopher or theologian, has the right to make an artistic representation the basis of a moral judgment on the artist's basic attitude or to consider himself a judge of nihilism, decadence, amorality, or even lying. What is apparently absurd may have a deeper meaning. Even the metaphors of a broken world, even the mechanical-surrealist human dolls of Giorgio de Chirico, the erotic drawings of Hans Bellmer or the "Vienna School," Francis Bacon's caricatures of popes, can certainly be the expression of an ultimately affirmative attitude. And even behind the nonsense of a dadaist or neodadaist collage of carvings drained of meaning there may still be a meaning: ironically, clownishly, satirically unmasking protest against the madness of war, the rationalism of the technical age, the mendacity of bourgeois culture, against false gods. "What we call dada," writes Hugo Ball, "is a fools'

game made out of nothingness, embroiling all higher questions" (in 1916 in his diary, *Flight from Time*). The very fact that a painter continues to paint, continues despite everything, can be the expression of an ultimately sustained basic trust. How much is involved here is shown by the terrible breakdowns of van Gogh, Munch, Ensor, like those of Rimbaud and Nietzsche. In any case, whatever attitude the artist personally adopts toward reality is *his* affair alone, but it really *is* his affair. For anyone who does not choose in this basic decision has in fact chosen, chosen not to choose: in this vote of confidence in reality, abstention means refusal of trust, in fact a vote of no confidence.

Art is play, and more than play. And the basic trust of which I am speaking here, as ultimate point of reference for men, for artists, means anything but an escape into the atmosphere and idyll of an unbroken world, as if art had conjured up an idealistic pseudoworld. What I mean is a basic trust which—like the appreciation of art, which also has the character of a decision—is certainly not rationally demonstrable, but not irrationally unverifiable, and can nevertheless be justified by reason. It is a basic trust in reality which, because of the abysmal uncertainty of this reality, demands both a critique and a change of unjust social conditions: an art which, precisely in virtue of this basic assent, can present even shabby, ugly, exhausted, shattered reality impressively—obviously on condition that this achievement is on a high artistic plane.

In anger and desperation George Grosz once declared: "It is irrelevant whether someone produces hot air or a sonnet of Petrarch, Shakespeare, or Rilke; whether he gilds bootheels or carves Madonnas. Shooting goes on, hunger goes on, lying goes on: why all the art?" I know: there are many artists today who try in one way or another to give a critical assent to this life, to this profoundly dubious reality, as it happens to be. "What we are mainly seeking is to provide an intellectual basis for the mutual understanding of all men," we read in the dadaists' manifesto of 1919. Hence very many artists today see their work as a critically constructive and wholly meaningful illumination, understanding, interpretation, portrayal, and mastering of this reality of ours. But in the unavoidable grappling with the pressures of reality they continue to ask if such an assent is really justified. I constantly experience meaning and value in my life, in my art and in the world, but will these endure? What am I working and suffering for? In the last resort is not my art, all art, perhaps in vain? Will it not perhaps be the sickly, the evil, fatal, null—often experienced with the same intensity and depicted often deliberately as disharmony particularly in modern art—that prevails in the end? What is the source of our life and what is its goal? Is there simply a "course of things" without reason, support, or goal, possibly going round in a circle? The artistic crisis of trust, of trust in art, is often the result of a general crisis of trust, of trust in reality.

Anyone who wants an answer to these very last,

very first questions, who wants to overcome nihil-
ism, not merely in practice by a general, vague
basic trust, but in principle by a justified, firmly
established, effective basic trust; anyone who
wants to solve the basic riddle of this always per-
sistently uncertain reality—that I exist, that things,
human beings exist, that the world exists, that
there is anything at all—is challenged to give an
assent that goes deeper: not only an assent to real-
ity in general but also an assent to a *ground of
meaning of this reality,* which as primal reason, pri-
mal support, and primal meaning secretly justifies,
sustains, and guides this reality of our life and our
world. An assent to the ground of meaning of this
reality is no more demonstrable than the assent to
reality as such, nor of course can it be refuted, but
it can be rationally justified. This is an assent to a
ground of meaning that thousands of artists have
attested through thousands of years in thousands
of images, so that the question may well be asked
what art would be without the religion from which
it emerged from the time of the cave paintings of
Altamira, the pyramids in the Egyptian desert, and
the great temples in Mesopotamia, in India and, in
Greece.

Willy Baumeister, the Stuttgart painter whose
pictures had been described as degenerate in 1933,
removed from the museums and partly destroyed,
wrote in 1950 against Sedlmayr, Hausenstein, and
others: "I protest against the summary assertion
that modern art is without ethical values and has
no binding ties—no *religio."* Perhaps in the last two
decades there is something that has been thrust

too far into the background: the fact that in the great breakthrough of modern art not only were merely questions of form involved but also spiritual impulses, the great questions of meaning—questions of the meaning of art, of color, of form, of life, of man as such. We may recall the crisis of impressionism and the critique by the symbolists of its positivism and lack of intellectual content. We may recall the letters of van Gogh and Cézanne or the diaries of Gauguin. We may recall Kandinsky's "On the Spiritual in Art" and the *Blaue Reiter*, the manifestos of dadaism, of the Bauhaus, of futurism, of surrealism . . . The great questions of meaning in art: in regard to these we may suggest a few, perhaps helpful, lines of orientation in the next chapter.

Art as Heritage, Anticipation, Elucidation of Meaning

Certainly, we are not taking anything back. Art may not be overtaxed, may not be identified with religion, to become a religion of art; art cannot produce and today does not seek directly to produce a meaning of life. But now think of the counterpoint: even though art may not be overtaxed, it may nevertheless be challenged. For every great painter transcends the visible in his own way, makes visible the invisible. And if art assists self-representation and experience of the world, serves to open up, interpret, and lay bare our reality, is it then to remain simply dumb in regard to the ultimate questions concerning this reality? Should it not again become more clearly involved precisely

in the great questions of the sense or nonsense of life? Perhaps also it should become more powerfully involved in virtue of a critically acquired orientation of life, of a tried and tested assent: in virtue not only of the courage to depict negative experiences, the ugly, the meaningless, but also of the courage to depict positive contents of meaning, values, feelings, the "beautiful" in this sense—the beautiful, that is, not as an innocuous sedative, but as a challenging evocation of the good made visible.

I do not mean of course that art should again become religious. Nor do I mean that art should deal mainly with religious themes and make use of the traditional symbols for transcendence. No, it is not possible to go back from autonomy to heteronomy and dependence. But should not the art of the future again become *open to religion?* Should it not mean going forward completely autonomously and independently to a new rootedness, to a new basic certainty, to a new firmly established basic trust? Not then an ideological-secularist art, which is constantly threatened by nihilism. But certainly a completely secular art with its hidden basis in an absolute ground of meaning, which—whether representationally as with Beckmann and Schlemmer or nonrepresentationally as with Kandinsky and Mondrian—perhaps by the arrangement of light and space would allow us to perceive something of the all-embracing dimension of the mystery of all things; which might indirectly throw some light on "what involves me unconditionally," as Paul Tillich used to describe it.

Whatever the attitude of the artist to religion, to the question of God, to belief or unbelief, the opportunities offered to him by a basic trust rooted in particular in belief in God are immense. Particularly for the artist it should be of the utmost importance not to leave unanswered the great questions of ground and meaning, whither and whence, which would otherwise become constant occasions of doubt, acquiescence, or rebellion. Also and particularly for the work of the artist it should be of the utmost importance to know *whence we come, whither we are going, who we are* (parallels between art and theology may be noted marginally here).

For the artist who knows *whence we come* a new relationship to the *past* is possible. This is a *first* point.

Anyone, that is, who knows in a completely justified trust that the world and man do not come from the nothingness that explains nothing, but from that ground of grounds which as primal ground is also primal goal of man and the world, will not make an idol of the past:

tradition will not be his God;

history will be important for his art, but will not become an ideology, will not become historicism.

No, I am not condemning here *historical consciousness, historicity* also in art (and theology). Every art is set in a complex network of historical connections. Nothing is to be said therefore against turning to history in order to take up cer-

tain elements from a past age or culture and quite freely to work them up into a specific shape and so create something that is really new. This is what the Renaissance and German Classicism did in their creative actualization of antiquity. This too is what the moderns—Picasso, for instance—have done, learning from the art of black Africa, the Hittites, Sumerians of the Iberian and Greek archaic periods, from the art of the Aztecs and Mayans, of the Middle Ages and the Renaissance, of the seventeenth or the nineteenth century.

What I reject is *ideological historicism* (still propagated, not least in ecclesiastical and neoconservative circles). I mean any kind of *religiosity centered on the past:* as if God had been linked only with a particular art (or theology) of the past, but had nothing to do with that of the present;

as if a particular art (or theology) of the past was a priori qualitatively better;

as if the old, instead of being a stimulant, had to be a model, something to be imitated, not merely evoked.

Anyone who finds his style solely by historical borrowing and is dependent on the imitation of a style betrays his creative weakness and intellectual impotence. At the same time, he may make an idol of the ancient Roman Empire or of Italian fascism, he may worship the Middle Ages, neo-Romanesque, neo-Gothic or Neo-Scholasticism. This sort of nostalgic historicism leads every time to anemic scholasticism, not only in theology, but also in art.

No, "historical fidelity," "traditionality," can

never be the supreme law in art (or theology); mere correctness of presentation results in naturalistic pedantry. As Nietzsche rightly analyzed, "historical awareness" of this kind becomes "historical sickness." Repetition and imitation of the past provoke its denunciation.

What is to be expected today from both state and Church, from both artists and viewers of art, is not an unreserved commitment to some part of the past, but a freely and critically discriminating attitude to our own history. Only in this way are we immune against that paralyzing myth of "decline" according to which in art also we have been going downhill ever since the Golden Age.

Anyone who believes in a first and last ground of meaning of the world and man can never believe in the ultimate decadence of man and his art; on the contrary, by looking back to the past, he can create a better orientation of life, can give greater meaning to life for himself, for his work, and also for other human beings. The great art of the past thus becomes for him an incomparably precious *heritage of meaning*.

For the artist who knows *whither we are going* a new relationship to the *future* is possible. This is a *second* point.

Anyone, that is, who relies in completely justified trust on the fact that human life and human history do not end in a nothingness that explains nothing, but are fullfilled in that goal of all goals

which as primal goal is also itself the primal ground of the world and man, will not make an idol of the future:

progress will not be his God;

the future will be important for his art, but will not become an ideology, will not become futurism.

No, I am not speaking here against *orientation forward*, against *futuristicism* also in art (and theology). Nothing is to be said against that deliberate orientation of art to the future which, against all conventional staticism, submits programmatically to the dynamism of history and incorporates the technological progress of mankind into the artistic argument. This is what the Italian futurists did as the first to be concerned with the artistic representation of movement, energy, speed, with a kinetic art.

What I want to warn against is only *ideological futurism* (certainly not propagated only in Italy and in art). I mean any kind of *religiosity centered on the future:*

as if God had come only through technological evolution or politicosocial revolution and as if art (or theology) had nothing to do with the past;

as if a new beginning had to be made again and again rigidly at zero and as if every revolt were itself a great renewal;

as if the very latest art were not only the first available, but the very first and best of all.

Anyone who pleads and works for a permanent revolution, for continual cultural or artistic revolution, for a new humanity to be produced immediately, is by no means promoting progress. Not

only do the Red Guards prove this but also Mar-
ietti's "futurist manifesto," his abuse of museums
as cemeteries, dormitories and slaughterhouses of
art, and his advocacy—inspired by enthusiasm for
the future—of dangerous living, of struggle and
violence, militarism, patriotism, war, that is, a
combination of futurism and fascism—according to
Walter Benjamin the large skeleton in the cupboard
of the modern movement as a whole. This sort of
all-out futurism can very easily lead to totalitari-
anism, in art as in religion.

No, "newness" or "novelty" can never be the
supreme law in art (or in theology); a radical
break with all tradition is by no means a guarantee
of anything better. Continually, rapidly increasing
change of fashion trends and "isms"—brought
about less by the immanent development of art
than by the constraints of exhibiting, of competi-
tion between galleries, of the art market, of the
mass media—is the expression of a craving for
novelty which sometimes promotes outlets for art
products but kills true art.

What is to be expected from both state and
Church, from both artists and viewers of art, is not
an irresponsible commitment inspired by a uto-
pian sense of mission to any kind of programmed
future, but a frankly and soberly realistic attitude
also toward the different utopias of our age.

Only in this way are we immune against the se-
ductive myth of "progress," according to which in
art also the Golden Age is immediately at hand.

Anyone who believes in a first and last ground
of meaning of the world and man can scarcely be-

lieve in the automatic ascent of man and his art; but, without fear of the future, precisely by his trust in an art of the future, he can create a better orientation of life, can give greater meaning to life for himself, his work, and also for other human beings.

The ever newly possible, always living art thus becomes for him a hope-inspiring *anticipation of meaning*.

For the artist who knows *who we are* a new relationship to the *present* becomes possible. This is a *third* point.

Anyone who in a completely justified trust admits that we are finite, defective beings and yet beings of infinite expectation and yearning, that we do not find an ultimate support in ourselves but only in that primal support which is also primal ground and primal goal of the world and man, will not make an idol of the present:

the present moment will not be his God;

the momentary impression will be important for his art, but will not become an ideology, will not become impressionism.

No, I am not attacking *impression,* concentration on the immediate present, an art which, without drawing pictures in the conventional sense, tries to capture and shape the fleeting impression of the moment, making use of "chance" as an artistic method in individuality, subjectivity, and spontaneity. This is how French impressionism carried out its artistic experiments with light, sun, and

color, becoming increasingly detached from the object.

What I am criticizing is only *ideological impressionism* (also manifesting itself in a completely different form in modern American art). I mean any kind of *religiosity centered on the present* in art (or theology):

as if God worked only through the momentary happening and as if history, looking both backward and forward, had no part to play;

as if only the unhistorical "eternal" present counted and history could be denied, the linkage with past and future ignored.

Anyone who stands up for the impressionist idea of art for art's sake too easily sacrifices art to its superficially beautiful semblance, lacking depth, substance, and detailed elaboration. This at any rate was the reproach of the postimpressionists who at an early stage feared a draining of meaning and content. This too is the reproach made against certain forms of American pop art, which took their sculptural themes and methods largely from show business and advertising, alienating these only slightly with the aid of screen printing processes and the like.

This kind of artistically noncommittal impressionism, concentrated on what is momentary, leads occasionally to naive cultural optimistic conformism, when it coolly and indifferently (without the power of French impressionism to create an atmosphere) accepts simply the commitment of the consumer society to the fabricated and artificially reproduced reality of Coca-Cola bottles, stereo-

types, and idols, and in naive poeticizing—unlike dada and surrealism, without critical awareness— explains them as the wholesome real world. ("Pop is liking things," said Andy Warhol.) Art here all too easily becomes kitsch, a cheap confirmation of the status quo. And even junk art, garbage art, land art, secluded landscape art, can then be uti- lized and exploited for entertainment by the mech- anisms of the culture industry, although they are less easy to preserve than the "fine arts."

No, "objective quality" or "actuality" cannot be the supreme law in art. Photographic fidelity, reli- ance on comic strips, environment, montage of real elements to form a picture—none of these in them- selves guarantee the artistic mastery of reality. Not everything that is interesting is for that reason art, not every happening is an art event. The metamor- phosis of signs, signals, and symbols of advertis- ing, traffic regulations, and the mass media can certainly convey aesthetic experiences. But occa- sionally all it can do is to reveal boldly and simply our modern philistinism, superficiality, sex obses- sion, and the banality of modern slogans and ap- peals, happenings and idol figures.

What is to be expected from both state and Church, both artists and viewers of art, is not a passive acceptance of prevailing conditions, but a critical attitude, aware of our temporality, particu- larly toward the banal, commonplace present state of our mass culture: an attitude which must in- clude both the remembrance of the past and look- ing ahead to the future ("This is Tomorrow" was the admonitory title of a London pop exhibition in

1956). Only in this way are we immune in our cheap "wear out and throw away" society against the myth of the "eternal return of the same," which Nietzsche saw as the reverse side of nihilism (admittedly, a nihilism of which many are not yet aware).

Anyone who believes in a first and last ground of meaning of the world and man, even at a time of the obsolescence of fashions and the disintegration of "isms," can scarcely believe in a definitive chaos of art; on the contrary, precisely out of his deeper understanding of the art of the present time, he can create a better orientation of life, can give greater meaning to life for himself, his work, and also for other human beings.

Art that is relevant particularly today, with all its enormous tensions and inconsistencies, then appears to him as an up-to-date *elucidation of meaning*. This will be made clearer in the sixth chapter.

Art as Service to Man

Art as heritage, as anticipation, as elucidation of meaning: as you see, there is a middle way between academic claims to style and antiacademic lack of style. Artists and viewers of art need not succumb either to the grandeur of the past, the fascination of the future, or the immediacy of the present. No, despite all handicaps, dangers, menacing disasters, as historical human beings we are all required continually to start out again, fully aware of the present, from the past that has been brought under control to a still disquietingly or gratifyingly open future.

In face of the crisis of orientation in art and life, I wanted to offer a basic orientation for this continually renewed journey and not to declare myself for or against any particular trend in art. The the-

ologian is neither *arbiter elegantiarum* nor *arbiter artium*. And there are many today who agree with this. The "great abstraction" and the "great realism"—as Kandinsky put it at an early stage—are two poles of the art of the twentieth century; they also represent two trends, but are by no means mutually exclusive alternatives. Representational art of the nineteenth century or nonrepresentational art of the twentieth century: this far too simple distinction has been falsified by the sensational return of object-related art itself. At the same time, the image of man largely lost in the art of the present century has again become visible, although distorted and alienated in a way that is typical of our time. But, whether art is representational or nonrepresentational, constructivistically rational or individualistically irrational, it is in any case in the field of tension between reality and unreality, fleeting appearance and symbolism. Under these circumstances may I be permitted to express in the form of an imperative—or, better, optative—that which many artists regard as decisive for their work: *art should be—may it be!—human, truly human, humane*—humanity, that is, understood seriously or not seriously, positively affirmed or critically denied. Yes, let the supreme norm for human art be, not conformity to tradition, not novelty or actuality, but *humanity:* a humanity grounded, protected, and secretly secure in divinity; a humanity which has practical consequences for human fellowship, for relations with our fellow men and with nature.

Let art be human: that is, whatever its themes

and styles, let it serve man and, against all modern dehumanizing of man, let it throw light on the still awaited humanizing of man. In the age of the mass media visual art has certainly no longer the *value as information* which it had at a time when the great mass of the people could read only pictures or only books. But, precisely in this age of the mass media, visual art acquires a *value for orientation and for life* which man today needs more than ever and which politics cannot replace. Art—and the new stream of visitors to museums and exhibitions proves this—has now its own evidence, power, and effectiveness.

Its particular service to man consists in symbolizing, without cold comfort or false solemnity, what is not yet, how man and society might be, what man's yearning awaits: in this world of purposes and constraints, a free space for the element of play which leaves open all possibilities. For a great work of art is more than the "manifestation of an idea," more than merely "resplendent play," and certainly more than a downright "lie." It is—particularly when it is aesthetically immanently perfected—more than a hint and anticipation of a world still awaiting its consummation. The perfected work of art today is seen as a provisional manifestation and reflection of a future consummation. In this connection I would like to quote a Tübingen philosopher of the present century. The work of art

proceeds from the longing for that perfect existence which is not yet, but which man, despite all dis-

appointments, thinks must come to be when the existent has reached its full truth and reality has been subordinated to actual entities. The tree on the canvas is not like that outside in the field. It is not "there" at all, but is placed, seen, felt as filled with the mystery of existence within the confines of the representation. The painter has given form to it in his vision and expressed his image in the external structure of lines and colors on the canvas in such a way that it can also emerge in the imagination of the person who contemplates this structure. The tree, however, is not sealed in its unreality, but rouses the hope—if it really exists—that the world as it ought to be will at some time actually arise. Thus art projects in advance something that does not yet exist. It cannot say how it will come to be; nevertheless it provides a consoling assurance that it will come. It is laid open, so to speak, behind every work of art. Something rises up. We do not know what it is or where it is, but we feel its promise.

This is not a quotation from the Marxist philosopher Ernst Bloch, but, as you will have guessed, from the Catholic philosopher of religion Romano Guardini. Both however, Bloch the Marxist and Guardini the Christian—even though with contrary assumptions and conclusions—agree in defining art as anticipation of a better world than the present, as expression of hope of a "new heaven" and a "new earth," however these are envisaged. Here I come to my conclusion.

Conclusion

Art and the question of meaning. At a time of threatening meaninglessness art helps (even by what appears to be meaningless) to keep to the fore, to provoke, the question of meaning and to confront us with it.

Yes, at a time of threatening meaninglessness, art helps (even by what appears to be meaningless) to arouse afresh through the senses and to keep awake the sense for meaning.

As recipients of art, we need for this the artist's imagination, creative power, civil courage, and integrity. For, in their wholly individual fashion, with their very varied methods of presentation, artists can help us human beings, often so lacking

in ideas, so helpless in all our activism, to test our
attitude to reality as a whole and especially to our-
selves, to perceive our condition of alienation and
to find our own integrity. With their sensible
codes, signs, and symbols, with colors, forms, and
shapes, they can give new meaning to life and thus
produce more vital energy, more profit to life,
more joy in life.

I began with the theme of the sickness and
death of art in a no longer humanistic culture. I
would like to end with the hope of its new life in
what is no longer a humanistic culture, but never-
theless one that is freshly human. Yes, I believe in
a freshly living art at the service of a new art of
life: an *ars viva* at the service of a new, more hu-
man *ars vivendi*, of which the *ars moriendi* as pre-
lude to the consummation is a part. And I am sure
that today also art, the work of art, can be a great
symbol, a great meaningful sign:

a symbol which, despite all difficulties and op-
position, can remind us human beings of the great
heritage of the past, the future still to be won, of
the meaning, value, and dignity of our life here
and now;

a symbol that can rouse our passion for freedom
and truthfulness, our hunger for justice and love,
our yearning for fellowship, reconciliation, and
peace;

a symbol which may perhaps enable us to per-
ceive something of what "involves us uncondition-
ally," the still hidden, incomprehensibly great
mystery in us and around us: that is, the suprasen-

sible ground of meaning of all our reality in the midst of the world of sense.*

*The philosophical-theological substantiation of the basic conception largely taken for granted here is found in Hans Kung, *Does God Exist? An Answer for Today,* trans. Edward Quinn (Garden City, N.Y.: Doubleday, 1980).

An Exchange of Ideas with Horst Krüger
on a Poem by Bertolt Brecht

Bertolt Brecht
Gegen Verführung

1
Lasst euch nicht verführen!
Es gibt keine Wiederkehr.
Der Tag steht in den Türen;
Ihr könnt schon Nachtwind spüren:
Es kommt kein Morgen mehr.

2
Lasst euch nicht betrügen!
Das Leben wenig ist.
Schlürft es in schnellen Zügen!
Es wird euch nicht genügen
Wenn ihr es lassen müsst!

3
Lasst euch nicht vertrösten!
Ihr habt nicht zu viel Zeit!
Lasst Moder den Erlösten!
Das Leben ist am grössten:
Es steht nicht mehr bereit.

4
Lasst euch nicht verführen
Zu Fron und Ausgezehr!
Was kann euch Angst noch rühren?
Ihr sterbt mit allen Tieren
Und es kommt nichts nachher.

Translators note. No translation could bring out the force and beauty of this poem. The following is merely an attempt to explain the meaning of the words for the non-German reader.

Against Seduction

Do not be misled!
There is no return.
Day goes out at the door;
You might feel the night wind:
There is no tomorrow.

Do not be deceived!
That life is a little thing.
Quaff it in quick gulps!
It will not suffice for you
When you have to leave it.

Do not be put off!
You have not too much time!
Leave decay to the redeemed!
Life is the greatest thing:
Nothing more remains.

Do not be misled
To drudgery and wasting disease!
What fear can still touch you?
You die like all the animals
And nothing comes after.

Horst Krüger
Against Seduction?

This poem is perfect of its kind: perfectly beautiful, perfectly clear. Is it also perfectly true? It defines Brecht's attitude to death. What is known as "dialectical materialism" (and what, with the classical authorities on Marxism, mostly set in motion an immense conceptual machinery) has rarely been expressed so simply, so graphically, almost in the style of a folk song. "Day goes out at the door;/you might feel the night wind"—the metaphors (and the rhyme scheme) belong to the tradition of the German lyric from Goethe's time onwards. There is also an echo of Romanticism, of romantic dissatisfaction, unquenchable thirst for life: "Quaff it in quick gulps! It will not suffice for you/ when you have to leave it!"

As almost always with Brecht, this is also a didactic poem. Indeed, in its didactic tenor it embodies practically the extreme case of tuition. It lives wholly on the pathos of enlightening instruction. "Do not be misled!"—the opening line goes through the poem to the very last line deliberately and quite unmistakably, like an educative index finger. That is how you ought to see it. That is how a teacher stands before his class. That is how a social revolutionary regards himself before his class.

Nevertheless, it is never didactically pale, theoretical, merely "enlightening." On the contrary, it is as if the drama and force of the theme of death had laid bare the poet's experiences of the ultimate depths. Wisdom, not knowledge, speeds on this instruction. It is the wisdom of resignation: "You

die like all the animals/ and nothing comes after."

What the poem means within the historical con-
text of Marxist enlightenment is obvious: enlight-
enment against clericalism and mysticism. The
Church's consolation of a better hereafter at the
price of mass poverty here, that is, also at the price
of stabilized, conservative conditions of owner-
ship, is abruptly rejected—and rightly: "Do not be
misled/ to drudgery and wasting disease!" It is a
passionate summons to take the present world,
earthliness, seriously, to exhaust it fully, and in
fact to develop the one and only life that each of us
possesses into a celebration of earthly abundance:
"Quaff it in quick gulps!" Such dionysian out-
bursts have the value of rarity in Marxist anthro-
pology which generally sees, and utilizes, man
more as a part of the economic process.

Nevertheless, the element of revolutionary ex-
plosive force contained in such statements seems
to me, in the light of the present situation, oddly
backward looking, as a critical argument against
Christian bourgeois ideology. As an attack on the
abuse of consolations of the hereafter it remains
relevant and true. But if we start out, for example,
from a utopia where socialism has been achieved
(where economic exploitation no longer exists), its
limitations are immediately apparent. I have al-
ways admired this poem, but in the last resort I
cannot agree with it. Death is simply hypostatized
as a clear break: "You die like all the animals." In
a sense this is true. But at the same time it slams
a door shut which, I think, should be kept open.

Whether with Bloch we call it "the principle of

hope" or with Jaspers "the borderline experience," death, declared in an almost authoritarian fashion to be the absolutely final break, is deprived of something quite tiny which constitutes its nature: the question mark. "Against Seduction"—Is this counterseduction?

Brecht's poem is in B. Brecht, *Gesammelte Werke,* 20 vols., Vol. II (Frankfurt, 1967), p. 527.
Krüger's interpretation is printed in *Frankfurter Anthologie,* Vol. IV (Frankfurt, 1979), pp. 172–174.

Hans Küng
The Alternative

If I had not met Horst Krüger, the interpreter of Brecht's poem, unexpectedly at a pre-Easter discussion, I would scarcely have read both poem and interpretation a week later with the same sense of involvement. But now, when I can still hear our lively conversation, as we agreed and disagreed, in the train from Cologne to Mainz, I cannot resist the challenge offered by the poem and its interpretation to add my own comments.

The theologian will not want to outdo the literary critic's praise of this poem, "so simple, so graphic, almost in the style of a folk song." "It is as if the drama and force of the theme of death had laid bare the poet's experience of the ultimate depths. Wisdom, not knowledge, speeds on this instruction." Nor can the theologian raise more precise questions than those of the literary critic: "This poem is perfect of its kind: perfectly beautiful, perfectly clear. Is it also perfectly true?"

The believer in God will certainly not deny the truth of the passionate protest by the atheist Brecht and the agnostic Krüger, in the spirit of Feuerbach and Marx, against unenlightened clericalism and mysticism, against the Church's consolation of a better life hereafter at the price of economic exploitation here: the protest, that is, against religion as opium, as a fraudulent means of social appeasement, consolation, seduction. No, "do not be deceived, do not be put off, do not be misled!" No hereafter in place of the here and now, no religion instead of politics, no Bible instead of reason, no

prayer instead of work, no being a Christian instead of being human.

But the counterquestion is for that reason also true: the here and now in place of the hereafter? Politics instead of religion? Reason instead of the Bible? Work instead of prayer? Being human instead of being a Christian? Does the one dimension necessarily exclude the other? Does not this poem "as a critical argument against Christian bourgeois ideology" seem also to Krüger "in the light of the present situation, oddly backward looking"? Can there be any doubt today that religion need not be opium, but *can* also be a remedy, a medicine, a means of comprehensive enlightenment and social liberation and often really was and is such, not only for Dag Hammarskjöld, Martin Luther King, Helder Camara, Mother Teresa, but also for countless unknown people? Can it be denied that there are people who believe in God and for that very reason also—although it is often difficult—are able to believe in men, and so to work for more humanity, to take quite seriously and "exhaust" fully the here and now, this one life in its abundance? All this of course today—in an age of the destruction of the environment and of man's inner life—without too much romantic-dionysian "quaffing in quick gulps." It must be done in the wisdom of sober resignation, aware of the limits of growth, the limits of any pleasure or success, the limits of all life.

Limits in the midst and limits at the end of all life, certainly. But does that mean nothing but decay at the end, death as the absolutely final break?

Here the agnostic Krüger rightly contradicts the atheist Brecht: "Death, declared in an almost authoritarian fashion to be the absolutely final break, is deprived of something quite tiny which constitutes its nature: the question mark." And the agnostic who attacks the "seduction" of the empty consolation offered by the bigot attacks also the desolate "counterseduction" offered by the godless person. He rightly wants "to keep the door open," like Karl Jaspers in his "borderline experience" or like Ernst Bloch who awaited death also with great curiosity and with death a *peut-être:* not only decay but, perhaps, redemption out of decay—something quite different.

Nevertheless, a further question occurs to me: must I be content with a "perhaps" throughout my whole life? Suspended in uncertainty between seduction and counterseduction, between pious consolation and impious desolation, am I never to find firm ground under my feet—liberated from scepticism and acquiescence?

To be more exact: it seems to me to be a rash and not particularly reasonable assumption that the end of all things, the end of all our great and small thoughts, ideas, wishes, of all our laboring, living, and loving, is simply decay; that everything ends in nothingness, that everything is in vain. Nowhere, it seems to me, is the final hopelessness and indeed the radical irrationality of atheism—often obscured by an "immense conceptual machinery"—as obvious as it is here. And Brecht, like Feuerbach and Marx before him, asserted but nowhere proved that in death—which he certainly

has in common with the animals—man simply dies into nothingness. Admittedly, no one has proved the opposite: death retains its question mark in any case. All knowledge ends at this point. There is no assured certainty for anyone.

But would it be possible to conceive another form of certainty which might remove the "perhaps"? Can it not be a completely reasonable assumption with my eyes open to trust that this decaying reality of man and the world is not and will not be for me the first and last reality:

that this reality is not self-explanatory, self-justified, self-fulfilling;

that it is sustained and contained by an absolutely first, absolutely last reality which ultimately falls into decay;

that man consequently does not die into a nothingness, but is transformed into that incomprehensible-comprehensive reality?

This, it seems to me, is likewise a bold, but, by comparison with that other hypothesis of an ultimate meaninglessness, completely meaningful assumption. Of course I cannot prove it by reason— tied as this is to our horizon of experience; but I can commit myself to it in a fully tested, enlightened, not irrational trust: a trust based on wisdom, not on knowledge.

As against all the nullity of reality, what is revealed here is the radical reasonableness and profoundly human consolation of that venture which is and remains a purified belief in God. This is a

radical reasonableness which has nothing in common with rationalism, a comfort which has nothing in common with empty consolation. For only as a godless person could I say that *everything* disintegrates with death. As a believer in God, I may consistently say that with death everything is transformed into God: *vita mutatur, non tollitur.* Understood in this way the doors that the atheist wants to close and the agnostic wants to keep open even now provide the trusting person with a brief glimpse of the great mystery of our life, which cannot be empirically verified but for which we may hope in trusting faith. A hope that bestows a fundamental certainty, taking away fear and constantly giving new power for the battle against "drudgery and wasting disease."

Bertolt Brecht's poem is an enlightening didactic poem, defending a thesis: according to Krüger "practically the extreme case of tuition." In other words: "That is how you ought to see it. That is how a teacher stands before his class. That is how a social revolutionary regards himself before his class." A didactic poem, which is not a sacred text, can be transposed in order to make the alternative clear. Brecht's atheistic poem should certainly not be theologized—appropriated in the usual manner of theologians—and interpreted as an implicitly religious poem. On the contrary, its atheism should be taken seriously and for that very reason the antithesis or, better, the overriding, transcending, transfiguring synthesis to Brecht's thesis should be presented. Out of respect for Brecht's challenge and taking it quite seriously, little is changed here:

two letters in the first verse, one word in the second, a little more only in the third and fourth. The didactic poem may then be read without the "pathos of enlightening instructions," without an authoritarian "educative index finger," but in a tone of calm conviction and friendly invitation: instead of a seduction by the bigot or a counterseduction by the godless, an initiation by the believer.

Es steht noch mehr bereit

1

Lasst euch nicht verführen!
Es gibt eine Wiederkehr.
Der Tag steht in den Türen;
Ihr könnt schon Nachtwind spüren:
Es kommt ein Morgen mehr.

2

Lasst euch nicht betrügen!
Das Leben wenig ist.
Schlürft nicht in schnellen Zügen!
Es wird euch nicht genügen
Wenn ihr es lassen musst!

3

Lasst euch nicht vertrösten!
Ihr habt nicht zu viel Zeit!
Fasst Moder die Erlösten?
Das Leben ist am grössten:
Es steht noch mehr bereit.

4

Lasst euch nicht verführen
Zu Fron und Ausgezehr!
Was kann euch Angst noch rühren?
Ihr sterbt nicht mit den Tieren
Es kommt kein Nichts nachher.

English translation:

Still More to Come

Do not be misled!
There is a return.
Day goes out at the door;
You might feel the night wind:
There is a tomorrow.

Do not be deceived!
That life is a little thing
Do not quaff it in quick gulps!
It will not suffice for you
When you have to leave it.

Do not be put off!
You have not too much time!
Does decay seize the redeemed?
Life is the greatest thing:
There is still more to come.

Do not be misled
To drudgery and wasting disease!
What fear can still touch you?
You do not die like the animals
There is not nothing after.